T0105811

What's Up?

by
Phillip House

Order this book online at www.trafford.com
or email orders@trafford.com

Most Trafford titles are also available at major online book retailers.

© Copyright 2010 Phillip House.
All rights reserved. No part of this publication may be reproduced, stored in a retrieval system, or
transmitted, in any form or by any means, electronic, mechanical, photocopying, recording, or
otherwise, without the written prior permission of the author.

Printed in Victoria, BC, Canada.

ISBN: 978-1-4269-2722-5 (sc)
ISBN: 978-1-4269-2723-2 (dj)
ISBN: 978-1-4269-2724-9 (e-book)

Library of Congress Control Number: 2010903994

*Our mission is to efficiently provide the world's finest, most comprehensive book publishing
service, enabling every author to experience success. To find out how to publish your
book, your way, and have it available worldwide, visit us online at www.trafford.com*

Trafford rev. 3/23/2010

 www.trafford.com

North America & international
toll-free: 1 888 232 4444 (USA & Canada)
phone: 250 383 6864 ♦ fax: 812 355 4082

High Five

by
Phillip

Together Again

Roses are red, violets are blue
Girl when I saw you, my heart was happy and true
Those blue eyes are like a ray of sunshine
That smile of yours just brightens my day.
I remember the time we sat in the park
What a fun and enjoyable experience together with you.
Fun, sun, and quiet times together with you are a dream that came true.
Let's walk in the park all the time
Let's keep taking picnics together
Let's walk, talk, play, and stay in love forever.
Always and forever, each moment with you
Is just like a dream to me that some how came true

Phillip House

be with him in trouble, I will deliver him, and honor him." John said, "Wow the Bible records that if a person abides in God, he can ask whatever he pleases, and God shall give him an answer to his prayer. I cannot believe that Mom." Rebekah said, "Whether you believe it or not that does not change the fact that it is true.

John said, "Mom, I have been doing many wrong things in my life; however, I called you because God impressed on my heart to ask you how I can be saved from the wrath which is after death which is called hell. I would also like to become active in some of the church's activities." Rebekah said, "Praise the Lord God Almighty, for another one of my prayers has just been answered."

The Power or Prayer

Once upon a time, there lived a spirit-filled woman who loved God. She studied the Bible day and night. Her life history read as though she tried hard to live by God's standards. She had one child who would not pray, nor would he participate in any of the church's activities. However, Rebekah truly trusted in God to save her child from the wrath that comes after death which is called hell or court. She prayed and believed that God would illuminate to her child that only through prayer can humans communicate with Him.

John, Rebekah's son, called her. He asked her "Mom, why is prayer a necessary force in your life?" Rebekah said, "Prayer is a necessary force in my life because of the legal system. God always answers my prayers. The Bible records that people who prayed to God received an answer. In Kings 9:3, Solomon says *and the Lord said unto him, I have heard thy prayer and thy supplication that thou hast made before me. I have hallowed this house, which thou hast built, to put my name there forever; and mine eyes and mine heart shall be there perpetually* Also, in 1 Kings 18: 37-38, Elijah says "*Oh Lord, hear me, that this people may know that thou art the Lord God, and that thou hast turned their heart back again.*" Last, but not least, Hannah, in 1 Samuel 1::27 says, "For this child I prayed and the Lord hath given me petition which I asked of him."

Rebekah said "I will read from the Bible some of the promises that are for people who pray today." In Luke 11:9, he says "And I say unto you, ask and it shall be given you; seek and ye shall find; knock and it shall be opened unto you." Also, in John 15:7, it says "If ye abide in me, and my words abide in you, ye shall ask what ye will, and it shall be done unto you." Lastly, the Bible says, in Psalms 91:15, "*He shall call upon me, and I will answer him: I will*

What's Up?

Prettiness

Twinkle, twinkle pretty girl you're the prettiest girl in the whole wide world. Girl, you are the dream I thought would never come true. You are the dream that makes my fantasy brand new. In this fantasy that I had of your one day you were attractive in a graceful and delicate way. Pleasing to the eyes and charming you are never the less in this dream you were a star. Then I awoke from my fantasy and retured into reality and you were just as beautiful.

"A" I love you
Z I'll never leave you
"A" I love you
Z "I'll never leave you

Visualize this,
Interpret it
She could tell he fancied her charm like a walk in the park on a summer day.
Cruising in my car with my girl and me exploring this wonderful world.
Cruising in my car with my girl and me exploring this wonderful world.

"A" I love you
"Z" I'll never leave you
"A" I love
"Z" I'll never leave you
Cruising in my car with my girl and exploring this wonderful world.
Cruising in my car with my girl and exploring this wonderful world.

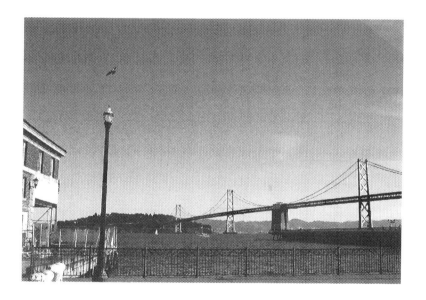

The Basketball Player

John goes from poverty to glamour and riches from playing basketball. Joe is John's basketball coach. Joe owns a strip club on the northwest side of town. One day two guys enter Joe's club looking for Palm who has a piece of jewelry that they want. They enter Joe's office while he is with a fifteen year old girl who is looking for work as a stripper. Joe has some drugs then right when he starts to get some, two guys enter his office to stop it, then give the girl a huge amount of money and tell her never to retrun there again. They beat the hell out of Joe, and they ask him where is Palm who has the precious stone. Joe does not know Palm. While they are leaving, the tell Joe they'll be back in five hours. Palm walks into Joe's club one hour later. She sells the jewelry to the the guys for $5 million dollars and Joe is off the hook. Joe is a coach who is coaching John.

John is the type of guy who was shooting basketball when he was six years old. John's team won his first championship when he was 12 in junior high school. John made the varsity basketball team his first year in school. He has a 3.5 GPA and his team won the state championship. John's girlfriend Rebecca also enjoys playing basketball and both of them received scholarships to NYU. John was an All-American in high school.

John traveled to NYU playing basketball. There was this one game where the score was tied 94 to 94 with one second and a person fouled John. John made the free throw and his team won. A pro NY team drafted John. Hew as given $60 million from Nike, plus a $5 million signing bonus and a salary of $11 million per year. John lives the good life as a professional basketball player. He marries Rebecca and their son Tom also becomes a professional basketball player at 19.

Rebekah said, "The Lord's Prayer". On this one trip, Rebekah was looking for the sexual pleasure of her life. She said, "John calls her candy because she is sweet like candy, taste like candy, and gets down like that. Picture this when they are in the bedroom what happen you complete the story. Her thing is so sweet. To John it tastes so good. Name your favorite sexual position. Rebekah is not looking for a one night stand she is the type who goes for one man only and that is John. She is a nasty girl. John looked straight into Rebekah's eyes. He felt a beautiful sensation from the top of his head to the bottom of his feet. He leaped in the air with great joy. He said to Rebekah "Twinkle, twinkle golden girl, you are the prettiest thing that ever walked on this earth. Girl, you are the dream that I thought would never come true. You are the dream that makes my fantasy brand new. In this fantasy I had of you, you were attractive in a graceful and delicate way pleasing to the eyes and charming. You are never the less in the dream you were a star. After I awoke from this fantasy and returned into reality. Rebekah was just as beautiful. I love you. John asked Rebekah would you marry me. She began to think. Marriage was something to think about. Thus, she said, "Oh John, you are the apple of my eye, of course, I will marry you. John and Rebekah started off being good friends which was the stage called alpha. Although they were good friends, but that was not enough for them, so they fell deeper in love. They couldn't live without each other, so they decide don marriage, the wedding was grand. The omega stages they got a home had three children and lived happily ever after.

One + One= Love

It was one of those cold winter days when the sky was gray and John came home from a tough, challenging and exhausting day at work only to find out that all hell had broken loose. John's father had come to the conclusion that it was time for John to pack his bags, hit the road, and taste the realities of adulthood. John was astonished with his decision because he was young, poor, and broke. He immediately went to Slow Lake.

The angry gray sky that hovered over his house and his father seemed more muted at the lake; the wind though, went with him, and the waters of the lake rippled with little eddies that even below the darkening clouds glittered in their northeast flow. John sat on a bench just south of the lunch stand and watched what was going on around him, hoping it would take away his grim mood.

A young couple walked by, hand in hand, their bodies wrapped in heavy sweaters against the chill of the afternoon, he wearing a tousled woven cap and she letting her long blond hair stray in the breeze. Just behind John a swallow sang, and in its song, joined a group of children whose high-pitched laughter made its own kind of music. The children carried brown bags filled with pieces of bread that they cast onto the water for the ducks, shrieking in dismay when a seagull grabbed a piece of crust.

John left home. He got on an airplane to Los Angeles where he got a job as an operator for the city of Los Angeles.

The alarm clock exploded in April's ear like a foghorn broadcasting warnings to passing ships and demanded that she awaken. April rose out of bed, cleaned up, and went to the airport. It was evident that she would enjoy the memory of this trip for the rest of her life. She was a young, smart girl. April had just graduated from high school and she had decided that for her

graduation present she and a girlfriend May, would visit America. They were living in India. While visiting America, April and May met a young man named John who worked as a bus driver for the city of Los Angeles.

He, too had just graduated from high school. They met when April walked up to John and asked him "How do I get to St. Mary's from here?" John said, "Girl you are so fine, May I have your phone number?" April said, "I live in India, however, I am here for two weeks visiting. I am at the Marriott and the number is 555-5555."

John said, "I am singing in the choir at St. Mary's and I am on my way there now. Maybe I can give you and your friend a ride there?" April and May went there with John and the concert was grand.

The next day, John called April and he asked her to have lunch with him. John, April, and May went for lunch at noon. April spent all two weeks with John and did not want to leave.

When April and May finally got on the plane for India, they talked about all the good time they had had in America.

April is a spirit-filled woman who loved God. She studied the Bible day and night. Her life history read as though she tried hard to live by God's standards. She did not have on child who would not pray, nor would he participate in any of the church's activities. However, April trusted in God to save her child from the wrath that comes after death, which is called hell or court. She prayed and believed that God would illuminate to her child that only through prayer could humans communicate with him.

John, April's son, called her. He asked her "Mom, why is prayer a necessary force in your life?" April said, "Prayer is a necessary force in my life because of the legal system. God always answers my prayers. The Bible records that people who prayed to

God received an answer. In Kings 9:3, Solomon says *and the Lord said unto him, I have heard thy prayer and thy supplication that thou hast made before me. I have hallowed this house, which thou hast built, to put my name there forever; and mine eyes and mine heart shall be there perpetually* Also, in 1 Kings 18: 37-38, Elijah says *"Oh Lord, hear me, that this people may know that thou art the Lord God, and that thou hast turned their heart back again "* Last, but not least, Hannah, in 1 Samuel 1::27 says, "For this child I prayed and the Lord hath given me petition which I asked of him."

April said "I will read from the Bible some of the promises that are for people who pray today." In Luke 11:9, he says "And I say unto you, ask and it shall be given you; seek and ye shall find; knock and it shall be opened unto you." Also, in John 15:7, it says "If ye abide in me, and my words abide in you, ye shall ask what ye will, and it shall be done unto you." Lastly, the Bible says, in Psalms 91:15, *"He shall call upon me, and I will answer him: I will be with him in trouble, I will deliver him, and honor him."* John said, "Wow the Bible records that if a person abides in God, he can ask whatever he pleases, and God shall give him an answer to his prayer. I cannot believe that Mom." April said, "Whether you believe it or not that does not change the fact that it is true.

John said, "Mom, I have been doing many wrong things in my life; however, I called you because God impressed on my heart to ask you how I can be saved from the wrath which is after death which is called hell. I would also like to become active in some of the church's activities." April said, "Praise the Lord God Almighty, for another one of my prayers has just been answered."

April joined the choir with John Sr. and John Jr. at St. Mary's. The church gave a concert and invited other churches. There were four churches there. John Sr. got to sing the song that he wrote called "Jesus is Real". Here are a few other songs that were

What's Up?

sung "Amazing Grace", "Just a Closer Walk With Thee", "Can't Nobody Do Me Like Jesus", "Jesus, I Love You", "Rock of Ages" and other great praise songs. Just having a good time praising God. The concert was grand and the people enjoyed singing praises to God.

Here are the words to "Jesus Is Real":

I love Jesus
I love Jesus
I love Jesus
Because He's real
He's Real
He's Real
He's Real to me
Jesus is so real
He woke me up this morning
Started me on my day
That Agape love that he has
Keep me on the right way
I love Him
I love Him
I love Jesus
I love Jesus
I love Jesus
I love Him
I love Jesus

There lived two young adults who fell madly in love with each other. They eventually got married and had three children. The two young lovers are John and April. Also, John went from being poor to becoming super rich that is true freedom. John

What's Up?

and April met in Los Angeles when they graduated from high school. They were good friends and they ventured off into a mild love affair. They would play as if their love came from heaven above. You know like it was true love. They would call each other on the telephone regularly. In addition, they would go to plays, movies, and parties together. Alpha is named for the beginning of their love affair. John is the genuine guy who is 5'11", attractive, athletic, confident, and fun. April is a model and travels a lot. She has appeared in ads for lingerie and done some Television programs. She has a slender body, sexy curves, with a 34-21-34. She wears a size 8 and is 5'5" tall. When she wears her mini-skirt and tops, that really turns John on. Sometimes she gives John her worn panties, bra, and nighties. The sexy cassette tape that she gave John is hot.

This mild relationship became warmer once John and April entered college. They both knew that without each other, their lives were like ships without sails. They had started holding hands by this time, or should I say, they were becoming close friends. They both thought their partner was a gift from above because they were truly in love. John was not rich; however, he got a great deal on a home where a person paid $87,000 on the house. The house went into foreclosure and John paid $200,000. John made $200,000 profit when he sold it one month later. Their love for each other was true as sure as the sky is blue. Nevertheless, love does not pay the rent or put food on a table or put gas into a car. Thus, they both decided that this great thing called love would be even better after they received their college diplomas. This is the middle state of the love affair before getting married. After they received their college diplomas, they both got good jobs. They would take small trips together. On this one trip, April was looking for the sexual pleasure of her life. She said, "John calls her candy because she is

sweet like candy, taste like candy, and gets down like that. Picture this when they are in the bedroom what happen you complete the story. Her thing is so sweet. To John it tastes so good. Name your favorite sexual position. April is not looking for a one night stand she is the type who goes for one man only and that is John. She is a nasty girl.

Their love for each other, at this time, was stronger than ever and as beautiful as the beginning of spring. They felt a day with each other as like winter. When thy were walking on the beach, hand in hand, John looked into April's eyes. He felt a beautiful sensation from the top of his head to the bottom of his feet. He leaped into the air with great joy. He heard bells, or should I say, "He saw wedding bells." After John took April home, he drove himself back home. However in the process of driving home, he started to dream about his life with April. It seemed like heaven. For a month, he pondered asking April to marry him.

John then wrote a letter asking April to marry him. It went like this: "Twinkle, twinkle golden girl, you are the prettiest thing that ever walked on this earth. Girl, you are the dream that I thought would never come true. You are the dream that makes my fantasy brand new. In this fantasy I had of you, you were attractive in a graceful and delicate way pleasing to the eyes and charming. You are never the less in the dream you were a star. After I awoke from this fantasy and returned into reality, she was just as beautiful as in his fantasy. John said "I love you." Then John asked April would you marry me? After John sent the letter to April, she began to think. Marriage was something to think about. Thus, she said "Oh John, you are the apple of my eyes, of course I will marry you. The omega is named for third stage.

In conclusion, John and April started off being good friends which was the stage called alpha. Although they were good friends, but that was not enough for them, so they fell deeper in love. Thus they couldn't live without each other, so they decided on marriage, the wedding was grand. The omega stage they got another home, had three children, and lived happily ever after.

Young Prodigy

Once upon a time, there was a child who had in her heart a burning fire to be successful. Lady luck knocked on her door at a young age. She heard her knocking, so she opened the door to let her in. After she came into her life, her life began to flourish with fine treasure. This lady luck is called consistency, faith, and belief. Akeelah learned this thing while going to St. Mary's so she could vault into a world filled with milk and honey. I would like to convey to the reader the acquisition and refurbishment of Coates Hall. That St. Mary's can feed and educate its pupils on a single site in Edinburgh. Being a small boarding school, the choir school started in around 1880 and acquired Coates Hall in around 1999. St. Mary's music school is for young prodigies. St. Mary's Cathedral young prodigies do dialy evensongs, two services on Sundays, weddings on Saturdays and public concerts.

I like the digital compact disc with Handel Messiah Comfort Ye. When that alto voice and the instruments sing Akeelah music accompanied with words that sounds great.

Akeelah is the creative genius behind the kid-singing group at St. Mary's, one of the most successful choirs in history touring London, America, Tokyo, Australia, New Zealand, etc. With hits like Handel's Messiah. At first Akeelah's dreams of riches had been illusory; however, Akeelah became rich and famous. Akeelah became a world famous star with St. Mary's help. Akeelah's popularity in America spread like an epidemic throughout the year 2004. Then the London recording studio form her manager and Phil was the record producer.

When the summer is here, Akeelah is in America. When she was about twelve years old, a friend and she started playing music in her garage that girl's name was Mary. Mary played the

piano while Akeelah sang. Then Julie joined the group. Julie who things intelligence, honesty, and integrity are three of the most important qualities in a guy. She goes to an all girls' school. Julie joined the band and she plays the violin. Then Joy became a member, and she plays the drums. They would go to the garage after school and play their music from 4 p.m. until late at night. They did everything together. Wow, they had lots of fun together playing their music.

Julie works and focuses on her school and working on her career. However, she makes a point to take time to chill and go out with the girls on the weekends to have some fun. She says, "I guess if you are going to work hard, you have to party hard." She figures it's possible to meet a hot guy has more to him than just wanting to meet hot girls at the playground for a slide.

Akeelah

The purpose of this paper is to convey to the reader how I observe Akeelah and the Spelling Bee, and I'll inform you of an objective description of her. A young girl eleven years old with a smile on her face, hair hanging past her shoulders in front of the microphone with hands on her blue jeans, that is Akeelah. I'll create a picture of Akeelah who is a smart, aggressive person who's unsure she may win the spelling bee. She is scared of going further after winning the school spelling bee. Stalling while Mr. President Bob works up her nerves then she finally gives it another try. She attends Crenshwa middle school and gets to go to a wealthy school with money for a good education for children. She talks to Dillon Chu then goes to the spelling club in the play area where the children either spell a word or shoot a basketball with three misses and a person loses.

The name of this child is Akeelah whose approximate age is eleven years old who skipped the second grade and is now in the seventh grad with outstanding physical characteristics like a nice smile with other physical characteristics of being young, slim, and healthy. Her texture of hair is black with coco skin. Her face shape is small and cute. Her eyes are black with a smooth bubble like nose and she has little ears.

Her body language is that of a smart, young girl that is cool. Her posture is straight, with gestures according to the environment like her humble yet cool mannerism and facial expressions. When she is up on that stage spelling a word, her voice has a pitch and timbre the enunciation of a smart young eleven year old. Her speech is cool with varied tone.

What's Up?

Akeelah has a great brain, nice face, smooth stomach with good hearing from ears. She has fourteen facial bones. Her legs consist of three bones: the patella, the tibia, and the fibula. Here muscles are strong with nice hands a mouth that gives correct spelling of words.

Akeela (B)

The purpose of this paper is to convey to the reader an inner life for Akeelah and the Spelling Bee while Akeelah is expressing it in her own language like the inner portrait of the child thoughts and feelings what she thinks and how she expresses herself verbally. As the camera rolls, we see the inner portrait of Akeelah she is eleve years old. She is looking at the spelling bee on ESPN and she sees a girl win and get rewarded. What are her thoughts and feelings? Akeelah is asked to be in a school spelling bee. She doesn't want to be in the bee. However, to avoid detention for all the days she missed class, she chooses the spelling bee. Akeelah won the school spelling bee.

In the section should convey to the reader Akeelah's ideas of being a good speller then receiving help from her president Bob, teacher and coach. Akeelah enjoyed playing the word game scrabble on the computer and the board game. She went from school spelling bee to the district, regional, and national.

When Akeelah was looking at ESPN, she said, "what is this?" The national spelling bee was on and the girl just won the title. Wow that was Akeelah imagining that one day she could be up there and win.

Akeelah said, "You know that feeling where whatever you do or don't do, you just don't fit in? I don't know the word for alienation, estrangement, and incompatibility. Nah those are not right, but there has to be a word for it that is how I feel all the time, my name is Akeelah and I am eleven years old.

I'll immerse myself in my character's viewpoint. I can understand how an eleven year old may verbally think and express herself. The thought and feeling Akeelah has as a youngster the portrait of that child of dreams that may be one day she will win the national spelling bee, and then, lo and behold, she wins.

John the Lover

It was a cold summer day in the month of July, and a woman was crying because her baby was nudging, shoving, and pressing her stomach. He forced his way out of her stomach. Then the doctor slapped him on his behind, he felt that he entered into a cold, cold world and the world was filled with hatred and violence. It was a grim, gray day, when he was born, the weather was another sign to John that his life would be a challenge. An encore to the doctor for his work.

Phillip House

John lived polluted by poverty and his descent into the hell of drugs, crime, and poverty was inevitable. The overall impression of John was no encore, and the supporting gevidence is drugs and crime. The sensory details are his cool slide walk with a limp and his soft voice. My felling is that if John opens his heart to God, he could become a teacher or whatever he would like to be because God can open all doors.

John lived in an area known for its easy accessibility to drugs and the area had a high crime rate. The neighbors peddled dope from sun up to sun down.

Prostitution was a local occupation that the young women and men were a major part of. The local police thought of the area where John lived as "being off limits to the conservative church going people." The police suggested that they not to there for their own safety. Although John's house had two bedrooms, seven people lived in the house. Also, the house had rats and roaches that made John's house their permanent home. The heating worked in the summer, but the heat would not work in the fall or winter. The running water poisoned John when he was a child. John ate mostly beans, rice, and potatoes, all food that was cheap, including the $1 specials at the store.

Phillip House

Because John's mother had seven children, she never felt that she should take the time out to make sure John did his homework. When John entered the fifth grade, his teacher recommended that he would do better in a special class for those students who could not keep up with the rest of the class. After John entered High school, he was so behind the rest of his classmates that he just graduated. John started hanging abournd his neighbors who peddled dope, and he got involved with drugs. First,

John peddled drugs to make some quick money. He made $900,000 and he got the BMW 500 which his girlfriend who gave him a son enjoyed riding in. the started to smoke some of the dope that he sold. One day, John realized that he was addicted to hard drugs. John started stealing to pay for his drug habit. He killed many people; however, he got caught robbing a local bank.

Although John got out of jail at the age of nineteen, he couldn't find a job. However, with interest, his $900,000 became a $1 million plus investments.

John's record stated that he participated in robbing a bank and he took drugs. This is the story of a poor fellow who spent most of his life in a filthy old ghetto. He went to jail for stealing some money and he got out of jail but he could not find a job. John had a hard life. The life in the ghetto does indeed proved hard for all the John's born there and one has to marvel that as many escape from that grim reality as they do. In Harlem, the likelihood that very few of it denizens will ever find their way out from these mean streets except with God's help. All things are possible with God's help.

The Roman Catholic Bishops conference released a pastoral letter on the stat of the union's economy. They cam down hard on the fact that so many Americans do not have access to even survival commodities. I have found that many woman with houses full of children managed to find the time to make their young ones study—not all of them, of course, but some like John.

John goes to a Catholic school with his $1 million. He gives the church $200,000 for letting him in. He earns his B.S. then his Masters. He builds a new church and he becomes the pastor. He reduces the number of people who become drug dealers and criminals and the president of the United States gives him two humanitarian medals. Look at how God works when a person gives him their life!

Jesus I Love You

P. House

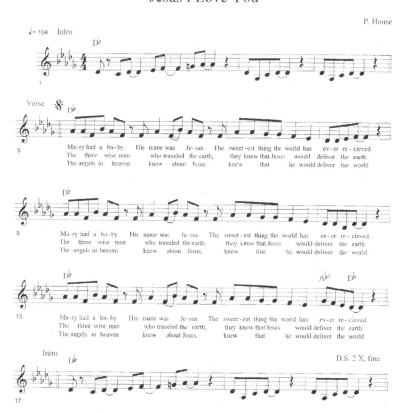

Ma-ry had a ba-by. His name was Je-sus. The sweet-est thing the world has ev-er re-cieved.
The three wise men who traveled the earth, they knew that Jesus would deliver the earth.
The angels in heaven knew about Jesus, knew that he would deliver the world

Ma-ry had a ba-by. His name was Je-sus. The sweet-est thing the world has ev-er re-cieved.
The three wise men who traveled the earth, they knew that Jesus would deliver the earth.
The angels in heaven knew about Jesus, knew that he would deliver the world.

Ma-ry had a ba-by. His name was Je-sus. The sweet-est thing the world has ev-er re-cieved.
The three wise men who traveled the earth, they knew that Jesus would deliver the earth.
The angels in heaven knew about Jesus, knew that he would deliver the world.

D.S. 2 X, fine

1 of 1

Jesus Is Real

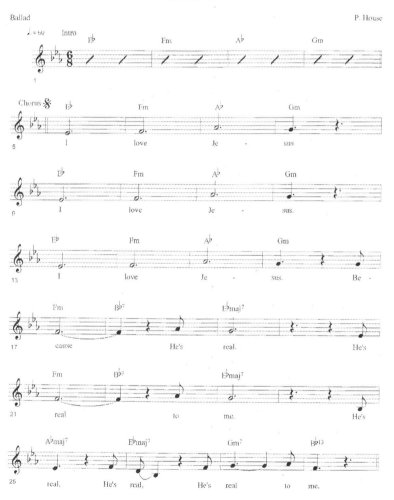

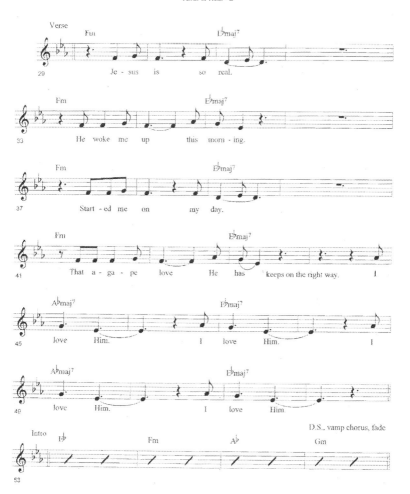

Phillip House

Whose Car Is This?

Rebekah said "The Lord's Prayer". On this one trip, Rebekah was looking for the sexual pleasure of her life. She said, "John calls her candy because she is sweet like candy, taste like candy, and gets down like that. Picture this when they are in the bedroom what happen you complete the story. Her thing is so wet. "Um come on John it tastes so good." Um name your favorite style of having sex.

Rebekah was not looking for a one night stand she was the type who goes for one man only and that was John. She is a nasty girl. John looked straight into Rebekah's eyes. He felt a beautiful sensation from the top of his head to the bottom of his feet. He leaped in the air with great joy. He said to Rebekah "Twinkle, twinkle golden girl, you are the prettiest thing that ever walked on this earth. Girl, you are the dream that I thought would never come true. You are the dream that makes my fantasy brand new. In this fantasy I had of you, you were attractive in a graceful and delicate way pleasing to the eyes and charming. You are never the less in the dream you were a star. After I awoke from this fantasy and returned into reality. Rebekah was just as beautiful. I love you.

John asked Rebekah "would you marry me."

She began to think. Marriage was something to think about. Thus, she said, "Oh John, you are the apple of my eye, of course, I will marry you. John and Rebekah started off being good friends which was the stage called alpha. Although they were good friends, that was not enough for them, so they fell deeper in love. They couldn't live without each other, so they decided on marriage. The wedding was grand. In the Omega stage, they got a home, had three children and lived happily ever after. John and Rebekah named on of their sons Frank.

A minor who lived with his parents, John and Rebekah, Frank entered into a contract with a friend that he had know for one year. The friend, David, offered to sell Frank a car for $3,000. Frank's parents had two cars. Frank worked part time and went to high school. Frank had $7,500 saved up for college. However, this quick talking friend took Frank to a garage where his car was being worked on and talked Frank into purchasing his car. David and Frank went to the bank, and Frank told David that he would give him $1,000 now and the other when he could drive the car to make sure that it was in good condition. Frank said, "If the car does not run good, David, you will have to give me my money back.

David said, "If the car does not run well, I will give you the $1,000 back. But I'm telling you the car is in great shape and runs great."

When Frank got hom, he told his father the great news that he had just purchased a new car from David. His father asked if the car was checked. Frank said, "I did not think about that. The car looked very nice from the outside." The father asked Frank if he had driven the car. Frank said, "N, I did not drive the car home because it was in a garage." Frank's father called the garage and garage owner told Frank's father that the car could not be fixed.

The next day Frank called up David and told him that his father wanted him to get is $1,000 back. David told Frank that he spent the money on his bills and he claimed that they had a contract and the car belonged to Frank.

The garage where the car was being fixed could not find the parts to get the car running right, and the garage wanted the

car off their property. David gave Frank the pink slip for the car and told Frank to pick it up. The garage owner would not give Frank the car until someone paid eth e$600 bill for the work he had done on it. The garage owner told David to pay the bill or he would sell the car. David did not pay the bill, so the garage owner put an ad in the paper and sold the car to a car rental agency.

The purpose of this essay is to adequately convey to the reader a full discussion of the liabilities of defendant to plaintiff. The plaintiff, David, leased a car from the defendant. David and Frank were going to a boat dance, and David went to a rental agency to lease a car. The rental agency rented David his old car. David said, "This looks like my old car." He drove the car away. On his way to pick up Frank, David ran into a tree. The Defendant had a car that generates revenue for his company. However, with a car or mechanical device one never knows when something may happen. There are many mechanical parts, and at any time, even in a new car, something may happen. In the lease was written "should the leased vehicle experience mechanical difficult during the term of the lease, the lessee will promptly return it to the lessor." The plaintiff was driving and he applied full force to the brake pedal, but the brakes failed to respond and he crashed into a tree, sustaining serious bodily injuries. The insurance company should cover $5,000 property damage and $15,000 hospitalization, harm, and humiliation.

David brought action to recover for personal injury harm suffered after the crash. To make up for the damage, the trial court ruled in favor of the plaintiff. After David received $15 million from the insurance company, he vaulted into the life. He

purchased a $1 million car that had it all. Now David is cruising in his car with him and his girl and exploring this wonderful world. Life was worth living with all its trimmings. He gave Frank $1 million. Strictly liable for products liability when a defective product causes injury, the manufacturer of the product, as well as the distributor, wholesaler, and retailer who sold it, may be liable to the person injured on a number of distinct legal theories, some in some in tort and some deriving from contract. Damages recoverable (e.g. punitive damages are not recoverable for negligence or for behavior without fault.) the liability insurance coverage, which may exclude some intentional torts. The U.C.C. provisions #776 the Uniform Commercial Code imply a product to have fitness for particular purpose. The product is generally fit for normal use (U.CC. #2-314). Plaintiff prevailed in a strictly liable action.

Defendant appealed with a counter claim on negligence and the court ruled in favor of the plaintiff for full compensatory compensation. If the defendant is knowledgeable that the plaintiff is aware of the damage and he did not respond, the defendant can bring a negligence action for the damage to the car. The traveling sales agent, once he began to notice that on occasion the brakes were not responding as well as they should have, returned the car for repairs and acquired a substitute until the original rental was ready. If the plaintiff had known of the damage, he should have foreseen that a major accident could have occurred. Defendant may prevail in a negligence action against plaintiff for breach of the repair contract, and the plaintiff's negligence being the breach.

After Frank got his $1 million he recorded a song called "Nella". It goes like this: The way you walk and talk it really set me off for a long time, yes it does. The way you look and cook it really got me hooked for a long time, yes it does. You're that golden star, you are that number 1 international bestseller girl. Yes, you are and that is what I like girl. Yes it is. First you tell her that you love here with all your heart, and then you tell her that you will never depart. Cruising in my car with me and my girl, exploring the wonderful world."

Phillip House

Just My Imagination

As my younger brother and I were on your way to the gymnasium to play basketball, James asked me, "What is the definition of 'Imagination'"? I pondered the question for a few seconds, and I said "I do not know; however, James, there is a library four blocks from the gym. We will first go to the library; then we will go play basketball." Five minutes later we entered the library, and lo and behold the first thing I saw in the library was a beautiful young librarian about twenty-nine years old. Her eyes lured me to her. I asked her if I had seen her before. She said, "What school do you attend?" I said "La Salle." She said, "I attend U.S.F." I asked her "what is your name?" She said "Judy." I said, "My name is Phillip."

James and I walked over to a table and sat down. I said "I should find the etymology, definition, and history of the word "Imagination". James and I walked over to the attractive young librarian and asked for Webster's Third New International Dictionary." She pointed to a large blue book on a table, which I took to the table. We returned and sat down. I read to James the etymology of "Imagination". Now, James asked, "What is the definition of "Imagination"? I read softly to him from the Webster's Third International Dictionary "1. An act or process of forming a conscious idea or mental image of something never before wholly perceived in reality by the imaginer. Also, the ability or gift of forming such conscious ideas or mental images esp. for the purposes of articistic or intellectual creation. 2a. Creative ability. 3. A plotting or scheming esp. of evil. 4a. A Mental image, conception, or notion formed by the action of imagination.

5. popular or traditional believe. James said "What is the definition in three other dictionaries. I looked up the word 'imagination' three more times, I found more well stated or three similar definitions to that of Webster.

Aftar I read softly the definition of the work 'imagination' to James, he asked me "What is the history of the word?" The Oxford English dictionary (OED) gaivs this history:

The first recorded date of 'imagination' used as a mental image or idea was 1340 by Hamploe is Psalter xxxxii. Various other authors used 7 Pe Fende bat, and it. The last recorded date in the O.E.D. for the word in that context was 1895 by Dk. Argyll in Philos. Believe 223. In 1385 is the first recorded date of 'imagination' being sused as a scheme or plot by Chaucer L.G.W. and the last recorded date in 1760 by H. Brooke in Foot of Quality {1809} III. 47.1340 was the first recorded date of 'imagination' being used as the reproductive 'imagination' by Ayenb. The last recorded date in the O.E.D. of this usage is in 1840 by Mill Diss of Disc. in Bentham {1859}. The first recorded date of "imagination" used as the operation of fantastic thought is in 1386 by Chaucer Miller's T. the last recorded date is 1834 by Medwin in Angler is Wales. The first recorded date of "imagination" being used as a function of the mind when in engaged in imagining was 1384 Chaucer H. Fame II.220. The last recorded date was 1662 by J. Davis Olearius' Voy. Angass (81.). After I finished reading to James the history of "imagination" I looked up at the clock on the wall which read 4:44 p.m. The bell for leaving rang in my ear like a foghorn warning to passing ships.

I asked James, "Wait for me outside; I'll be right there in a few minutes." It seemed like I was in spotlights in a fashion show as I walked over to the librarian and asked her if she wanted to go to

the movies. She said, "Sure" and gave me her number. As I was walking outside, I thought "Wow! I missed playing basketball today because James wanted to find out the definition, history, and etymology of imagination; however, I got a hot date with Judy, a beautiful Librarian.

Golden Gate Park

The purpose of this paper is to convey to the reader a description of a place called Golden Gate Park.